Muse

DAWN MARIE KRESAN

The first edition of *Muse* was published by Tightrope Books, Toronto, 2013. The rights reverted back to the author in 2018.

Published and designed by DK graphic design
Author photograph by Michelle Bowman

The author acknowledges the generous support of the Ontario Arts Council, through their Writers' Reserve Program.

ONTARIO ARTS COUNCIL
CONSEIL DES ARTS DE L'ONTARIO
an Ontario government agency
un organisme du gouvernement de l'Ontario

LIBRARY AND ARCHIVES CANADA CATALOGUING IN PUBLICATION

Kresan, Dawn Marie, 1974–, author
 Muse / Dawn Kresan.

ISBN 978-1-9994548-0-7 (pbk.)

 1. Siddall, Elizabeth—Poetry. I. TITLE.

PS8621.R474M87 2018 c811'.6 C2013-901974-X

Muse

Elizabeth Siddal was born in London, England, in 1829, the daughter of a cutler. She was working as a milliner's assistant in a dressmaking shop in 1849 when she was "discovered," and began modelling for members of the Pre-Raphaelite Brotherhood—Walter Deverell, William Hunt, and John Everett Millais. Introduced to Dante Gabriel Rossetti soon after, she modelled for him exclusively and became the primary subject of his numerous sketches and drawings. Rossetti encouraged her artistic and poetic study, and helped secure patronage from John Ruskin in 1855. She debuted her work at the Pre-Raphaelite salon at Russell Place in 1857. Her volatile romance with Rossetti continued for nearly a decade, was briefly ended, and then in 1860 they suddenly married. By his own account, it was only when he believed her deathly ill that he proposed marriage. In 1861, she delivered a stillborn daughter, suffered from depression, and became addicted to laudanum. In 1862, she died from an overdose. The coroner's report listed the overdose as an accident, although there were rumours that a suicide note she left pinned to her dress was later destroyed. In a symbolic gesture, Rossetti had his manuscript buried with his wife. Later regretting the decision, he had her body exhumed to retrieve his poems. Siddal's small artistic output would be forever overshadowed by her role as Pre-Raphaelite model, mistress, and tragic muse.

CONTENTS

I

II

III

I

Woman is muse or she is nothing.

—ROBERT GRAVES

I stretch my hands in the long grass
And fall to sleep again,
There to lie empty of all love
Like beaten corn of grain.

—ELIZABETH SIDDAL

Found — *How she was found by walter deveral*

Chosen for your curious grey eyes, voluminous
hair with a ginger sheen—a bonnet-shop girl

plucked from obscurity, brought into
his circle of loose-haired women and luscious colour.

Before his touch, the world was an empty
canvas longing for exotic Venetian hues.

With every caress, cerise and vibrant blues.
Here, you found a place for yourself.

In a world glossed with splendor,
why would you dream of darkness?

Still Life

He does not like to paint bowls
of apples and pears, or roses
decaying in a light filled vase.
The scarcity of an object
frightens him, the nakedness of a face
in saturated light. Cheekbones cut
by shadow. He surrounds his women
with subtext. *Crowns of dainty blossoms,
thick furs, birds in flight.*
Symbolism crowds her.
Leaves and flowers, stylized, packed flat
against the canvas. Her eyes are open,
yet she's locked within.

Housebroken

The Pet, Walter Deverall, 1852. Oil on canvas.

She stands in a doorway, on the threshold
between home and garden, peers inside
a bird cage. It is no wonder pets love their captor—
well fed and doted upon, the canary is full of melody,
the dog lazily snuffles at your feet.
No cares gnawing at the bone.
All kindness and kisses. *So you think.*
Protection has its costs.
Birds flounder in sorrow. Wings clipped,
they feel for the hand reaching in as one feels toward
a punishing god. Yes, they are pampered, fed
treats daily until docile and blithely paunch.
The dog, taught to beg for affection, must always
please. If it disobeys, the hand that now lovingly
strokes the ear's soft cushion, will strike
quick as lightening. Pain pulsing
through its skull, the high pitched yelps, its nose
rubbed into the mess it made.

15

Possession

Portray ⟨is trapping the woman⟩

Cinched at the waist, the corset embraces
you as though it were a lover.
A firm hold to keep
you buttressed
against
unruly inner
expansion. Restraint is
attractive in a woman, a rigid
upright back and disciplined curves.

*constricted
to
this role / look*

Ophelia in Love

one of the Pre-Raphaelite movements most famous Paintings

Ophelia, John Everett Millais, 1851-1852. Oil on canvas.

quiet = Submissive

You lie hushed in a bath,
heavy fabric branching out. Water
burrows in lungs. *restricted*

How perfectly you demonstrate devotion—
the descent into madness. *Ophelia killed herself*
Sickness a small price to pay for art. *when Hamlet rejected her love*

Close your eyes,
imagine a journey among reeds. Floating
with nettles nested in hair, tangled
and trailing…

A cut flower among other cut flowers.

Text to Image to Text

Tennesoyn – Lady of Shallot

Fetish

Fallen in love with lancelot

Text a response to Two Images

capture different Moments

The Lady of Shalott, William Holman Hunt, 1857.
The Lady of Shalott, Dante Gabriel Rossetti, 1857.

Moxon Tennesoyn

The death of a beautiful woman is, without question,
the most poetic of all topics, at least according to Poe.

Edgar Allen Poe _Atlantic_

Hunt and Rossetti seem to agree. Across the pond, they argue
over who illustrates what: the moment the curse takes possession

or the moment the corpse cruises down to Camelot.
Both want the dead woman, but Hunt acquiesces.

A moment of transgression and sexual surrender
is still doable. Cracked mirrors and curses can be fun.

No longer satisfied

Hunt a stern moralist in sexual matters, at least
when it comes to how women behave.

Hunt _Shadow for Substance_

The lady's hair is disheveled, her arms bare.
Tapestry threads bind her feet,

cocoon around

as if to punish her for daring to leave. _Purpose to Punish_
Certainly she is culpable, he thinks.

Rossetti, for his part, focuses on the wonderment felt
at a dead woman beautifully boat-floating.

Her face turned, surrendering to the viewer's gaze.
Her body stuffed into a corner,

her feet cut off by the frame's edge.
What is it with these guys and feet?

Foot Fetish

sinister brotherhood

Elizabeth Looking at a Portrait of her Husband's Lover

Bocca Baciata (the kissed mouth), Dante Gabriel Rossetti, 1859.

She gazes back, all lusty orange
and lemon-yellow. You suspect

she has a robust laugh. Her wide face
crowds the canvas. Hair spills, unbound.

How is it that she fills his eyes, while you
dwindle?

 Your gossamer form
floating, legless under blowing skirts.

Hers remains grounded, grows substantial.
Skin exposed and florid,

so unlike the dim water-
colours of you. Your bloodless skin.

A Bacchante, *Fanny Cornforth*

Just a model, he tells you,
but you know better.
You too were once his model.
You agreed to sit for him only
if a chaperone present. But this woman
goes to the studio alone,
makes easy company with men.
She stands too close and laughs
too loud, holding a hand at her breasts,
as if to draw attention
to the dip of cleavage. Who is this woman
who is nothing like you?
Face large and round, she cracks
walnuts between her teeth,
spits out the hard shells.
Accepts payment in beer.

Blush

Venus Verticordia, Dante Gabriel Rossetti, 1864-8. Oil on canvas.

Roses bloom extravagantly
against her skin.
Its perfect paleness
abated by a slight pink,
as if a statement
on the rush of blood
such a woman produces.
Ruskin, too prudish to snivel
about sensuality, condemned
the flowers' coarseness.
The respectability of roses
in question.

Black Beetle Through a Microscope

Purple-black, shiny as polished stone,
it once burrowed in the soil, signaled to its mate
by fanning out its leafy antennae.

Fetched from the kitchen to compare to Dürer's art,
its dissected body now extended
under a microscope. Shell flayed.

The professor remarks how Dürer's drawing captures
the beetle's likeness. How accurate
his art to anatomy.

You nod your head. Wonder at anatomies
on display, how bodies are framed
through the lens of an eye.

The carcass, no longer useful,
discarded with the rotting vegetable roots
and rancid meat.

Viridescent

Self-Portrait, Elizabeth Siddal, 1853-54. Oil on canvas.

He painted your gaze downcast,
claimed the right to control
what your eyes gathered in.
Yet, in this, your only self-portrait,
you stare back—
those large, sad, eyes, confronting.
Hair neatly pinned,
a quiet deception—
there is defiance
in your sharply drawn nose.
All around you green—
marsh, singed leaves, sap, wormwood,
at once sweet smelling
and choked with decay.

[handwritten annotations: "other paintings", "bring to light", "conflict", "Humility", "active agency", "Submissiveness", "Feminine characteristics", "Defiance (sees herself)", "Images of dead language, presence Elizabeth siddal, self through Portrait", "Voicing Siddal her", "reconstruction of an imagined siddal", "RESPONSE"]

23

Doppelgänger

How They Met Themselves, Dante Gabriel Rossetti, 1851-60. Pen and brush.

I

Incapable of reconciling
your many faces, a strange, yet familiar dread
stalks you. You cannot see the burning moon,
only hear the cries of animals howling. The brushwood lush
with fear. Your mind a dense forest canopy
no light can penetrate.
You sense you are being followed.

II

After years of separation, he has returned to you.
It is your honeymoon. Amid the soaring towers of Paris, he offers
a premonition in the form of a drawing.
A curious gift, certainly,
for a husband to give his new wife.
You stare at the willowy woman swooning
toward the earth.
What shock, *or is it sadness*,
has overtaken her, arms outstretched as if reaching to touch
her earlier self?
In a letter he writes, *I'm afraid this time
she will die.*

The Mirror Dance

The Bower Meadow, Dante Gabriel Rossetti, 1871-2. Oil on canvas.

The women are posed, told not to move
while he paints them strumming chords. Their fingers

idle away time while instruments lie still
in their laps. Her dark hair in thick rolls, pinned

with a silver barrette like some rare seashell. The other
woman's bright copper locks a startling contrast.

Indifferent to each other, they face opposite
directions, as if playing solo. Their bodies bend

into a frame, the space between them a window.
See two women dancing. Arms wrapped around waists,

they waltz, careful not to step on the other's feet, avert
eyes so as not to be drawn into pale flowered irises.

In the distance doves take flight,
a woman runs through uncut grass.

Caged Bird

Veronica Veronese, Dante Gabriel Rossetti, 1872. Oil on canvas.

Fed up with beauty,
you withdraw, body dissolving
between folds of shadowed satin.
You no longer hear the violin's song.
The dying jungle surrounds.

A purse, sewn from a predator's
pelt, dangles at your side.
A picked daffodil wilts.

Tucked behind, a canary
looks from its metal cage
to a sky it can no longer touch.
Your attention is elsewhere.
Spring has left.

Confinement

Doctors visit often.
Insist your mind is overstimulated.

They warn—imagination a danger.
Confine you to bed. The curtains are drawn.

You no longer trust the darkness.
Keep one eye open, scanning

the invading night.
The walls are advancing.

You hear them whispering strategies, plotting
the deployment of chairs, the hostile

take-over of the window.
Feel the dresser's encroachment,

slyly advancing. Shut in,
the walls entomb you.

You toss, try to free yourself,
swaddled in starched white sheets.

Interiors

You admire your belly big
as Jonah's whale. A living house
of fleshed-out interiors.
A tender bone architecture
where another hides, tucked inside
cradled darkness.
You have difficulty buttoning
dresses. Corsets won't fasten.
Your body—expansive, blown large
before your delighted eyes,
spanning out to great distances.
You chart the progress,
measure your belly's ample swell.
Trust the current that ripples
beneath the surface.

Stillbirth

You push out
dead weight,
waiting for a cry.
But there is no gasp
of air and sudden scream.
Placing small hands
between yours, you rub
vigorously to force
heat in. Open
her mouth, push
in breath, inflate lungs
like some god.
Darkness is all you see.
The black pits
of her eyes, an inky
blotch of blood.
The world holds
no light for you now.
You tunnel underground
with your newly-born dead,
bury her
in that desolate place
where nothing more
will thrive.

Disappearance

You peer inside
an empty cradle, head bent
as if in prayer, hush people entering.
Shhh, quiet, you'll wake the baby.
Long silences broken by outbursts
of brief rage.
No one can explain your illness—
yet all believe it serious.
Suggestions of a curved spine, offers
of tonics, ivory dust, powders boiled
until gelatinous.
Your only relief,
laudanum.
It slows your unraveling. Quiets
the voices.
One day you disappear. No note
hurriedly written, left on the table.
Only questions remain.
When you return, promises
are made.
Things will be better.

Cradle Song

It follows you everywhere—

this smell of motherhood, a musky dampness between thighs,
the sickly sweet scent of milk leaking from breasts.

You imagine she's crying,
hungry,
 mouth fluttering like a bird's, but you cannot move. Tethered
 by the chair's indifference.

You have looked into the cradle before, only to find her face receding.
Tearful eyes dissolve into stoic sheets. Cries
fade back.

 Surrounded by dusty papered walls, you slump.
 The worn chair. Dull ferns.
Magnolias tumble toward you,

 then slip away.
 You sing a lullaby, *rock-a-bye, rock-a-bye.*
Measure out laudanum
into a glass,
 its oily drops coiling
 down.

How to Escape Demands

There are no demands to care for younger siblings, fix dinner, and press sheets if your back is sore when you stand for long periods, if you refuse to eat, pushing the roasted vegetables and morsels of flayed meat to the side of your plate, if you cannot find the time for social engagements, refuse to dress in buttoned-up lace, if you tell them you are tired and have female problems... you will be free of the domestic duties most women cannot escape.

There are no demands to scrub floors, cook pot roast and potatoes, or have dull sex if you sleep more than you should, if they don't know why you're sick but say that you are, insisting warmer climates would do you some good, if doctors think your art drains and overtaxes your delicate female mind, recommend smelling salts or a mineral spring bath, if your prescription is to stop painting and the agony stitches your spine tight, if you take laudanum for pain... you will be left alone to work on your art.

There are no demands, none at all, when you take one hundred drops of opium every day, dissolved in a glass of alcohol, for medicinal reasons of course, if your hunger is gone, despite offers of rosemary lambshanks, croquettes rolled in breadcrumbs and lavender-scented tea, if they encourage you to do the things you once loved, but you cannot see past the blinding pain of each drawn-out day, if the only way you survive is to imagine your life different... you will tell people not to disturb your sleeping child, though she is dead and buried.

A Victorian Beatrice

Beata Beatrix, Dante Gabriel Rossetti, 1864-1870. Oil on canvas.

He chose you as his favorite model,
made you both mistress and student.
For hours you sat motionless,
the feeling in your arms gone dead,
while he drew you thin and pale,
with hands and mouth curled shut
like a bud not yet bloomed.

The illness that kept you weak, withdrawn
into darkened rooms with blinds snapped shut,
did not affect your splendour. The dove
places a poppy in your hands. Your hair,
an ecstatic red.

He thought you looked most beautiful
while sleeping, painted you languid
and heavy-lidded, as if your eyes
had nothing to say
except when mirroring his own.

Heaven & Hades

The Blessed Damozel, 1875-8, Dante Gabriel Rossetti. Oil on canvas.
Proserpine, 1874, Dante Gabriel Rossetti. Oil on canvas.

Lizzie reigns over the heavens,
while Janey rules the underworld.

Lizzie, enthroned in clouds, waits
for her earth-bound lover, indifferent
to the stars braiding her hair,
the bored trio of alabaster angels.

Janey, as mistress, sees her lover
seasonally. Loitering in court,
she squanders her time
sucking pomegranates.

Opposites some would say, and yet,
the same doleful eyes gaze out—
seeking the one who lies beyond,
as if anticipating his touch.

Rebirth

When you died, he declared
his muse forever lost. As the coffin's lid

lowered, he tucked a manuscript
between cheek and hair. A dramatic

gesture, befitting the first Dante.
Seven years later, at his command,

a bonfire was lit, your corpse
exhumed—hair rumoured

to fill the coffin,
rubescent and coiling.

His manuscript removed. Each page
disinfected. The stench of alcohol

dissipating as pages flap wet
on a line. Still, his soggy poems

could not be deciphered.
Ink smudged, as if by a wet thumb.

Brides with Plots: A Three-Act Play

I

Your dying takes all night, curled in a bed you no longer love in.
He thinks you are asleep, insists you look
still lovelier than before.

Your death, the final tragedy in a Shakespearean
drama—a child, born dead, heroine
gone mad. Exquisite death,

you fall lightly to the stage as women
press tissues to flushed cheeks.
Thunderous applause.

II

Each time he paints you, you die again. His signature, a bold
slash, enacts your vanishing. The role
of muse requires

many deaths. Your portrait hung in a gallery.
We feed with hungry eyes or plod
pass disinterested,

never aware of your pain's
brilliance. The opiate's
anesthetization.

III

He did not expect transformation—your mutation
into a mythical creature an impromptu
performance. You stalk him

in nightmares. The stories performed
are no longer his.
He wakes

in a cold sweat. Dreams
of being buried
alive.

II

Pluck me no rose that groweth on a thorn,
Nor myrtle white and cold as snow in June,
Fit for a virgin on her marriage morn:
But bring me poppies brimmed with sleepy death

—CHRISTINA ROSSETTI

Where are your opiates, your nauseous capsules?
If I could bleed, or sleep!
If my mouth could marry a hurt like that!

—SYLVIA PLATH

An Open Letter to Mr. DGR

You paint in the open air, blend pigment and boisterous colour, fill the emptiness with dense masses of vegetation. You can hear it among the green canopy of trees—a thin, trilling song. She is lost and wants to come home. Her face appears to you. Her perfect mouth a delicate rosebud. Do her eyes trouble you? Sad and distant, their grey an ocean of rough water, a stormy sky. You cannot lead the way. You tell her to loosen her hair, drop a bright golden rope to climb. You could live with her forever in that song-filled foliage.

Little Lizzie Snow

I

Under the hemmed skirt of darkness,
you run fast through unmapped terrain—

the growth of all that is green
in this night-time forest. Grass sprouts between
your toes. In strange twilight, seed pods burst.
Large trees bend, round apples bobbing

like so many moons.
You drink, and eat, until full.

II

The world unfurled and you thought yourself free.
But you woke inside this enclosure, like a butterfly

pinned within a case. *Here lies Elizabeth*, framed
in a glass coffin, crimson lips embalmed.

Poppies strewn at your feet. You grow weary of waiting
for your prince, hands folded in prayer.

It was supposed to be happily ever after,
but here, in your bed, there is only frost.

A drift of snow bars heavy against the glass. Your heart
avalanched. You lie still. Dream of a spring thaw.

III

He smokes with friends, discussing artistic brotherhood
while you clean stiff brushes, the stench of turpentine
stinging your eyes. Beyond the grey-granite sills of a small
window frame, a memory returns
of cerulean night skies,

 then it is gone.

It begins to snow. Ice on the cheek
where he kissed you last.
Paint forms a skin in open tins,
begins to crack—

Painter Without Hands

interested in her as a model not as anything else

She weeps over useless stumps.
What is the point of keeping oneself clean
and sinless if the body will be torn
from itself in either case?
Her desire is to paint, to hold
the smooth varnished handle, cup
saturated shades in cracked palms, the citrus
dye of a liquid orange daybreak.
Butchered, the knob-boned shorn-skin twists
like thick branches blown from a trunk,
bluntly chopped short before the edge of sky.

III

her soul is never to bloom, nor her bright hair to fade...
all she might have been must sink... in that dark house

—DANTE GABRIEL ROSSETTI

O Pale and heavy-lidded woman, why is your cheek
Pale and dead, and what are your eyes afraid lest they speak?

—ARTHUR SYMONS

Sylvia Plath Writes an Obituary

We shall not sleep,
 though white poppies grow.

 We are the Dead.

Admist fierce flames,
 where red poppies blow.

The Opiate's Seduction

The poppy beckons you,
its whorl of sedative stamens a promise
of undying devotion. *Come with me*, it says.
I will take away your pain.

At first, you refuse its budding beguilements.
But the day-to-day clatter of pans continues
alongside your coffined reveries.
You find it harder to resist.

Drawn in by its crumpled beauty,
its adornment of the dead, sometimes
you believe its ruffled charms,
its capsuled intoxications.

The sound of its familiar voice,
soothing and familiar—
Lay down your head, it softly calls…
Sleep, my pretty. Now you will sleep.

Elizabeth Siddal and Marilyn Monroe in Conversation

They sit and chat, stir cream into coffee,
like long-time friends swapping recipes
over the kitchen table.
Since their deaths, they've spent
barely a minute apart.

Lizzie, as Marilyn calls her, loves
to curl Marilyn's hair with an iron.
Wishes such things were invented
in her day. Marilyn teaches Lizzie
the proper way to apply mascara.
They giggle like schoolgirls
into the wee hours.

They organize study groups and book clubs,
complete with egg salad sandwiches
and jasmine green tea.

They relate to Hardy's tragic heroines,
bite their lips when reading McCullers.
Tennessee Williams often sparks a debate
over the worst kind of lover.

But Goethe is their favorite.
Young Werther's death scene
always turns on the waterworks,
each offering the other a tissue.

They share stories of unhappy marriages,
lost children and drug addictions.
Lizzie preferred laudanum, Marilyn diazepam.
Revealing the details of their deaths,

they promise never to tell.
Cut the tips of their forefingers,
and gently press them together.

Burning Bright

—after Christina Rossetti's "In an Artist's Studio"

He finds passion, *here*, in the blood-furl
curl of her hair, and *here*, in the curve of her lips.

He feeds upon her face by day and night.
In distant skies—her angelic symmetry.

Her beauty held safe, corseted
in satin brocade and tied with devotion.

Not as she is, but as she fills his dream.
Assured of her love, his world burns.

The fire, once hers, locked-in
behind his escutcheoned eyes.

[Handwritten annotations:]
William Blake "The Tyger"
A sonet xmas Eve — not mine
— appearence
— isn't what she actually is detached from reality
Artist (brother) is obsessed with his model and her looks

53

Elizabeth Responds to Christina's *Goblin Market*

Christina, let me tell you plainly
goblin men don't hide in dusty alleyways
selling orchard fruits, sun-kissed and forbidden.
They are the men you know and love. Artists
with a lustful curiosity for lower class girls,
their interest beyond the play of light
on the slope of a shoulder. They do not offer
plum peaches and rare pears, but gifts
of furs, dresses of magenta silk,
crowns of profuse delicate buds.
They offer paints of swirling sapphire, glittering
emerald and amber. What grey-stone girl
could say no to such intense colour?
You think sisterly love saves all, but what do you know,
sitting with your nuns? You, jilted by a false suitor,
thinking yourself above other women, alone
with your god. Reserved and pious, a dried rose
shut in the pages of a book.
Your brother saved me from austerity. Taught me
the beauty of pure pigment, the vibrancy of blue.
Now he is leaving. Goes dancing with other women,
brings them to his studio to paint their faces,
adoring him. I no longer inspire him, he no longer
offers me colour. Do you feel
any compassion for me, sister?
You, who reject me as your brother's wife,
dismiss me as a butcher's daughter.

Versions of You

In the hushed morning I read accounts
of your life, written by everyone but you. Your words

few and scarce.
I am drawn to your tragedy, my life quietly

lived among books filled with passions
that are not my own. It is the sadness

in your silver-flecked eyes I seek,
to feel what you once felt. To see beyond

gilded surfaces, to own the grief
that empties itself again and again.

But such things are never as they seem.
Rumours of a destroyed suicide note. Gossip

running in mouths. Hair
that grew in death. What I know of you

is mythology.
He painted what he wanted to see in fading oils,

erased your words, rubbed out
what you intended to leave behind.

My love never pure. He divides us,
standing between knowing.

Muse

By what authority do I speak of you—
sordid red metaphor through my colourless hands.
Your dead child and forgotten art used to enrich mine.
I ask you to saturate my mind with liquid lines.
Instead, you fill me with skies of silver blue.
Satin dresses that hold sadness in their folds.

Recruited by rosser: / as a mael after siddaly death

Elizabeth and Jane Morris at a Museum Exhibition

ACT ONE
SCENE ONE

Kresan Places siddal and morris in conversation

& Discuss Rossetti's work

Interior: the museum in morning.
Paintings adorn the walls.

Jane is standing in front of Rossetti's *Astarte Syriaca* when Elizabeth enters. Each says hello politely. They have decided to put their differences aside, to forgive personal jealousies. Feeling awkward, they turn towards the canvas, seeking answers. Astarte's large figure dominates, fabric rippling from broad gleaming shoulders. A classical pose with fingers pointing to sex. Jane examines this woman, barely recognizing her face hidden under the stylized hair.

You're not as masculine looking, Elizabeth offers. She cringes afterward, realizing how it sounds.

I suppose, Jane says, wrinkling her brow. *He certainly knew how to make a statement…* (Her words trail.)

Elizabeth fills in the blanks.

Oh, look at us, talking about HIS art. There are other paintings here.

They walk, the tides of people urging them along, all strangely silent. Earphones on, listening to audio tour tapes. The deep baritone voice of an art historian discusses the role of women as archetypes. They walk along lines marked on parquet floors, do not cross the velvet ropes separating them from images that tumble out, alarmingly, from frames. In front of *The Dance of the Veils*, they observe the seduction meant for a male viewer, a woman's thigh coyly guarding the source of her power. Her beauty distorted in menacing angles. Dangerous and alluring, her breasts sharp as blades. An authoritative voice tells of Picasso's love for Olivia, how she deceived him, posing for another artist, though he forbade her to go out alone.

Elizabeth:

They say he changed lovers with each
artistic phase. Changed women as casually as clothes.
I suppose it's unrealistic to expect a man of genius
to stay committed to one woman.

Jane:

Which man do you mean?

SCENE TWO

Interior Monologue

Elizabeth thinks of saying to Jane:

We wanted to see what he saw, to try and make sense of it. And I'll tell you now that we can contrast his use of colour, or talk endlessly of his differences in rendering our faces, but we will never understand.

Consider this: we thought the canvas could reveal something in ourselves we could not see. But we were wrong. It is not a window, but rather, a mirror. He admired his own face in the hard surface. We can never see through it. Let us instead look to one another.

Tell me how you see yourself.

Domestic Goddesses in the Kitchen

No longer wanting to be mythical,
she quarters apples and throws away the seeds.
Sprinkles on cinnamon and nutmeg,
for a fall harvest pie. After all, an apple
is sometimes just an apple.

Food for Thought, *Dorothy Wordsworth*

 You fed upon nature, expansive
sea, spotted white and darker lines, streaked. Horizon no border
to your ever-changing eye. Sought not to contain. Opening

 Opening to green mossy orchards, fresh haystacks in fields,
 darkly-ploughed, turnips a rough green.

You taught him to see. Traveled on foot, roads rough and
unmarked. Double leather sole of shoe worn away.
Fields stretched before you.

 Your eye did not calculate
bounds. Paid no regard to fences. Only noted forms of distant
trees, light shone full and wide on vivid eyes,
devouring. Tracking the moon.

 You fed him lamb-chops
 seasoned with sage and rosemary. Bread and pies.
Crust baked to a light crisp. Stalked woods for the sweetness
of apples. You fed him nature,

the light-filled moon, flowers that reeled and danced, words
picked from a tree, words that fell lightly, lightly
to a plate, ready to be served.

Mrs. Beeton's Cooking Class

In today's class, Mrs. Beeton, looking rigid
in her high ruffled collar, stirs her béchamel sauce.
Dorothy dips a finger into the simmering pot,
takes a quick taste. Thinks of her life with William.

The pot roast she made on Sundays, seasoned
with fresh thyme and basil she picked
from the tiny garden behind the house.
While she pushed away from the table,
he asked for more.

She gathered metaphors, spun stories
of gypsies and beggars, scanned the rolling hills
and fields of daffodils. She harvested
images, fed him words served
alongside tea and warm buttered toast.

In class Mrs. Beeton demonstrates to Dorothy
how to peel an artichoke. Blanched and tender,
she slowly pulls the petals down
and away from the velvety center.
Dorothy forces in her thumb,
smiles at her clumsy hands

Mrs. Beeton laughs, reminds her students
to savour the pleasure of their creations.
Her corset is drawn tight, the layers of crinoline
full under her skirt, yet things have changed.
She now talks of *jouissance*, of pleasure
scooped with a persistent tongue.

Elizabeth and Robert Graves attend my poetry reading

[handwritten annotation: Directly responds to quote]

From behind the podium, I see Elizabeth in the audience. Unmistakable. Her delicate face. Long heavy masses of red hair. The bell of skirts angling out from her waist. She, being the subject of my poetry, thought it only proper to come. Next to her, Robert looks ridiculous. His clothes rumpled, tie uneven. He is in a rough mood, already on his third cherry brandy.

Nervous, I read my poems quickly, finger the edges of paper. The audience politely claps as I walk back to my seat, sink down into the overstuffed chair and hope no one is looking. I glance over to Elizabeth and Robert, see them noisily weaving through chairs toward me. Robert, obviously drunk, knocks over a glass.

[handwritten annotation: Can women write?]

Standing in front of me, he rails against modernity. *You do a disservice to the white goddess*, he shouts. Arms waving wildly. *You are no poet! You can't write poems unless you're in love.* And then mutters something or other about mother night, paradise, how his own mother drove him to drink.

Elizabeth soothes him like a child—*now now*—taming his electric hair with a wet finger. *Never mind him*, she says. Ever polite, she gives me her hand, says my poems are lovely, but quickly adds, *I do not remember events quite that way.*

Epitaph Series: Imagined Engravings on Elizabeth Siddal's Tombstone

I

Here lies a poet with golden hair
Known to be beautiful and fair,
There came a prince who swept her away,
Till death do you part their one-act play.

II

There grew a gentle babe inside this frame,
But joy is never the artist's domain.
Soon fate befell, a destined stillbirth,
And now we live here in the gentle earth.

III

Scandal is never proper to discuss,
Yet in this grave are tales of deceit and lust.
Forever my chaste mouth shall remain shut,
Unless, like my husband, you dig coffins up.

Tarot Reading

I stare at the cards—pointed arrows piercing flesh,
a woman hung upside down in a noose, knot drawn tight.
There is talk of a family curse passed down from my mother.

A tragic fate, I must walk a dark wooded terrain.
But not all is lost. I can be saved for fifty dollars more.
Her face obscured by a cascading beaded curtain,

shining crystal balls dangling like so many planets.
Still dressed in a robe, although mid-afternoon. She asks
if I mind that she smokes. I do, but say nothing.

Jesus presides over the reading, his ceramic arms
outstretched. She pats the head of her terra cotta god,
as if a good luck charm, then takes my hands,

orders me to pray. This modern-day gypsy
insists I trust her—cut the cards and imagine a future
she has spun. Painted nails click as our planet orbits

the universe, indifferent to Pisces' constellations.
A tiny star among other points, too vast to comprehend.
We bend our necks in prayer, invent

worlds and stories to sustain us.
We look at a beaded curtain and are asked to see
the universe suspended on a shimmering string of light.

Trance Writing

I wake from a nap, pen and paper
close at hand. In my drowsy state,
words stream fast.
A broken fence still banging
against the hinges of my mind.
Firm in intent, a hand grasps
the bars tightly.
In the porch of an aged house,
a glowing orange light flickers.
A gnarled white cat guards
the entrance. She will not
let me pass, stretching open
her paws, claws extended.
This is where I find you.
On the threshold.
Gates knocking on hinges,
doorways revealed but impassable.
Are you the steadying
hand, holding me strong
against a storm,
or the frightened animal
marking a barrier?

The Séance

Friends gather in this semi-dark room
to summon you, his dead beloved.
His new lover silent beside him.

I am also in this circle,
though he doesn't know it. We link hands,
close eyes, are asked to focus on your smile,

the sweet way you blushed when laughing—
kind memories thought to attract
the newly deceased.

A cold breeze passes. Was the window
left open?

In dim candle-light, we hover. You, the spirit
he once loved, and me, a presence from the future.

I interpret events, open channels in time,
rap out messages with my ballpoint pen.
We sit in quiet anticipation.

He asks if you like his most recent painting.
Always ready to play the part,
you respond with a series of knocks—

tap tap rat-tat tap.
Interpretation left for another day.

Elizabeth Paints a Second Self-Portrait

In heaven, paint is free.
God encourages everyone to take art class.
Creative expression should not be underestimated
in its ability to heal old wounds.
He used this therapy himself.

No longer on the path of destruction—floods, fires, the usual antics
of a wrathful god—he now teaches art. Soothes the spirit
with yellow ochre and burnt umber. Like children, they paint
with their fingers, smear the palest blue
into the whitest paper.
 This is the sky.

Elizabeth does not participate.
She has other things to work on.
She looks to the clouds, imagines the sun, paints
her face for the second time. There is no hint

of darkness, no deep shading to the side of her nose.
This time, she paints herself smiling,
though no one will see it.

ACKNOWLEDGEMENTS

I would like to acknowledge the financial support of the Ontario Arts Council for their assistance in the completion of this manuscript. I would not have been able to finish this book without their generosity.

My heartfelt gratitude to those who encouraged me and helped shape these poems. Special thanks to Karen Connelly, Olive Senior, Karen Solie, Marilyn Dumont, Carmine Starnino, and Myna Wallin.

Some of these poems have been previously published in *CV2*, *Event*, *The Windsor Review*, *The Antigonish Review*, and the limited edition chapbook *Framed* (2009). The first edition of *Muse* was published by Tightrope Books in 2013, and I will forever be grateful to Halli Villegas for bringing this book into existence.

AUTHOR'S NOTE ON THE SECOND EDITION

This second edition maintains the original three-part structure of the first. Some of the poems were edited to sharpen their imagery and enhance their musicality, while a few of the weakest poems were excised. I was a different person when I wrote the first collection, and since my younger self believed she had something important to say, I changed nothing that would alter a poem's intent.

SELECTED SOURCES

These poems incorporate historical fact with my own musings. Some of the books I used to research Elizabeth Siddal and the culture she lived in were:

Auerbach, Nina. *Woman and the Demon: The Life of a Victorian Myth.*

Auerbach, Nina & U. C. Knoepflmacher. *Forbidden Journeys: Fairy Tales and Fantasies by Victorian Women Writers.*

Bronfen, Elisabeth. *Over Her Dead Body: Death, femininity and the aesthetic.*

Curl, James Stevens. *The Victorian Celebration of Death.*

Dijkstra, Bram. *Idols of Perversity: Fantasies of Fin-De-Siecle Culture.*

Gilbert, Sandra M. & Susan Gubar (eds). *The Madwoman in the Attic: The Woman Writer and the Nineteenth-Century Literary Imagination.*

Hares-Stryker, Carolyn (ed). *An Anthology of Pre-Raphaelite Writings.*

Hosmon, Robert Stahr (ed). *The Germ: A Pre-Raphaelite Little Magazine.*

March, Jan. *Pre-Raphaelite Sisterhood.*

Marsh, Jan. *The Legend of Elizabeth Siddal.*

Owen, Alex. *The Darkened Room: Women, Power and Spiritualism in Late Victorian England.*

Pearce, Lynne. *Woman image text: Readings in Pre-Raphaelite Art and Literature.*

Prettejohn, Elizabeth. *The Art of the Pre-Raphaelites.*

Prose, Francine. *The Lives of the Muses: Nine women & the Artists They Inspired.*

END NOTES ON POEMS

Section I
The line by Robert Graves is quoted from his book *The White Goddess*. The lines quoted by Elizabeth Siddal are from her poem "A Year and a Day".

"Found"
Legend has it that Walter Deverall discovered Elizabeth Siddal in a milliner's shop off Leicester Square, although the man described in my poem is Rossetti. The men of the Pre-Raphaelite circle are rumoured to have called female models of extraordinary beauty "stunners."

"Housebroken"
It is thought that Siddal modeled for Walter Deverall's "The Pet". An inscription on the painting states, "But after all, it is only questionable kindness to make a pet of a creature so essentially volatile."

"Ophelia in Love"
John Millais used Elizabeth Siddal as his model for his "Ophelia" painting. She was posed lying in a bath wearing an ornamental gown, and candles were placed beneath the tub to keep the temperature warm. During one of the sessions, Millais became so absorbed in his work that he did not notice that the candles went out. Siddal said nothing. She caught a severe cold, and later her father threatened legal action against Millais if he did not pay the fifty pounds in medical fees and loss of wages. They settled on a lower amount. Later accounts exaggerated the cold so that it became pneumonia. The last line of my poem is quoted from the French magazine *Je Sais Tout* (1907).

"Fetish"
The tragic heroine from Lord Alfred Tennyson's poem "The Lady of Shalott", first published in 1833, was loosely based on Arthurian lengend. The 1857 edition of Tennyson's poems included illustrations by Pre-Raphaelite artists.

"Elizabeth Looking at a Portrait of her Husband's Lover"
Fanny Cornforth modeled for "Bocca Baciata", "Fazio's Mistress", and "Lady Lilith". After Siddal's death, Cornforth moved in as his housekeeper. Her cockney accent and lack of education shocked family and friends, who openly ridiculed her.

"A Bacchante, *Fanny Cornforth*"
Rossetti met Fanny Cornforth, a known prostitute, in 1858. She became his model and mistress. William Bell Scott, in his *Autobiographical Notes* (1892) wrote of Fanny's and Rossetti's first encounter: she was "cracking nuts with her teeth and throwing the shells about; seeing Rossetti staring at her, she threw some at him. Delighted with this brilliant naïveté, he forthwith accosted her and carried her off to sit to him for her portrait." It was rumoured that Cornforth would sometimes be paid in beer in lieu of money for modeling services.

"Blush"
Rossetti's painting "Venus Verticordia" was modeled by Alexa Wilding, a dressmaker whom Rossetti discovered. When Ruskin condemned the painting, Graham Robertson, one of Rossetti's patrons, wrote in a letter to a friend: "Of course roses have got themselves talked about from time to time, but really if one were to listen to scandal about flowers, gardening would become impossible."

"Black Beetle Through a Microscope"
Ruskin sent Siddal to Oxford to be examined by Dr. Henry Acland, a physician and old friend. While in Oxford, the Warden of New College, invited her to compare a black beetle drawn by Dürer with a real one examined under a microscope.

"Doppelgänger"
"How They Met Themselves" was a painting based on an earlier drawing. Rossetti reproduced it while on his honeymoon in Paris. It is double-dated in the monogram: 1851-1860, thereby stressing the early and late relationship of the couple. The last line of my poem was quoted from Rossetti's letters.

"Disappearance"
Georgiana Burne-Jones described visiting Siddal after the birth of her stillborn child. Elizabeth was "sitting in a low chair with the childless cradle on the floor beside her... she cried with a kind of soft wildness as we came in, 'Hush, Ned, you'll waken it'."

"A Victorian Beatrice"
"Beata Beatrix" was begun in 1864 and not finished until 1870. Siddal originally modeled for the painting prior to her death in 1862. Posthumously, Rossetti worked from these earlier sketches. The painting depicts Beatrice, from Dante's *La Vita Nuova*, at the moment of her death. In a letter to William Morris, Rossetti states that he intended the painting "not as a representation of the incident of the death of Beatrice, but as an ideal of the subject, symbolized by a trance or sudden spiritual transfiguration."

"Heaven & Hades"
Jane Morris modeled for "Proserpine", and Alexa Wilding for "The Blessed Damozel".

"Rebirth"
Thomas Hall Caine, in *Recollections of Dante Gabriel Rossetti* (1882), described how Rossetti put the poetry book into Siddal's coffin, placed "between her cheek and beautiful hair", and then how one night "seven and a half years after the burial, a fire was built by the side of the grave and the coffin was raised and opened." Charles Howell claimed "her red hair had grown in death until it filled the coffin, retaining its glowing colour." Three pages from the exhumed notebook have survived. One is in the British Library.

"Brides with Plots: A Three-Act Play"
The title "Brides with Plots" is a phrase used in Anne Sexton poem, "Sylvia's Death".

Section II
The lines quoted by Christina Rossetti are from her poem "Looking Forward". The lines quoted by Sylvia Plath are from her poem "Poppies in July".

"Little Lizzie Snow"
This poem was inspired by the *Snow White* fairytale. Also in my mind, were the words of Georgiana Burne-Jones: "I had been used to… in many ways sharing the life of the studio—and I remember the feeling of exile with which I now heard through its closed doors the well-known voices of friends together with Edward's familiar laugh, while I sat with my little son on my knee and dropped selfish tears…"

"Painter Without Hands"
This poem was inspired by the Grimm's fairytale "The Girl Without Hands".

Section III
The lines quoted from Dante Gabriel Rossetti are from a letter he sent to William Allingham. The lines from Arthur Symons are from his poem "Pale Woman".

"Sylvia Plath Writes an Obituary"
The quoted line is from John McCrae's poem "In Flanders Fields", which he wrote after the funeral of a friend and fellow soldier during the First World War.

"The Opiate's Seduction"
The italicized lines at the end of the poem are spoken by the bad witch in *The Wizard of Oz*, when Dorothy encounters a field of poppies.

"Burning Bright"
The title comes from the first line of William Blake's poem "The Tyger". The italicized lines are from Christina Rossetti's poem "In an Artist's Studio".

"Versions of You"
Rumours circulated that Siddal left a suicide note pinned to her dress, and that Ford Madox Brown instructed Rossetti to burn the note so she could have a Christian burial.

"Elizabeth and Jane Morris at a Museum Exhibition"
Rossetti's affair with William Morris' wife Jane began after Elizabeth's death, but there is an interesting opposition between Rossetti's artistic renderings of these two women I felt compelled to explore.

"Mrs. Beeton's Cooking Class"
Some scholars argue that William Wordsworth sometimes pinched images from Dorothy Wordsworth's journals for use in his own poetry, infamously her daffodils. Beeton wrote cookery and etiquette books in Victorian England, such as *Mrs. Beeton's Book of Household Management* (1861).

"The Séance"
After Siddal's death, Rossetti occasionally held séances to contact her. The spiritualist movement was prominent in artistic circles in late Victorian England.

Dawn Marie Kresan is an author, editor, and graphic designer. Her books include *Muse* (Tightrope Books 2013), and *Derelict* (Bilbioasis, forthcoming). She co-edited the anthologies *Detours: An Anthology of Poets from Windsor & Essex County* with Susan Holbrook (Palimpsest Press 2013), and *Canadian Ginger* with Kim Clarke (Oolichan Press 2017). Her poetry has appeared in a number of literary journals, including *Antigonish Review, Carousel, CV2, Dalhousie Review, Event, Lichen, Prairie Journal, Queen's Quarterly, Vallum,* and *Windsor Review,* and in the anthologies *Whisky Sour Town* (Black Moss Press 2013) and *By the River* (Urban Farmhouse Press 2017). Her poem "Evolution" was long listed for the CBC Poetry Prize in 2016. She lives in Kingsville, Ontario, with her husband and their daughter.